The Magic of Airbrush Art

Hobby Series Book 1

By Cindy Wright

The Magic of Airbrush Art
Hobby Series Book 1

Cindy Wright

Copyright © 2013 by Cindy Wright.
Published by CW Books

All rights reserved. No part of this book may be reproduced or transmitted in any form or by any means, electronic or mechanical, including photocopying, recording, or by any information storage and retrieval system, without permission in writing from the copyright owner.

This book was printed in the United Kingdom.

To order additional copies of this book, contact:

Email:
cindys.great.books@gmail.com

Website:
http://uniquebookqueen.com/dirwp/bookstore

Other Titles by Cindy Wright

A Career in Hospitality

A Journey through the Histories of the Provinces of the Republic of Ireland

Aerobics: A Guide to Keeping Your Heart and Body Healthy

Acupuncture

Airbrush Art- Hobby Series Book 1

Balance and Heal your Life with Reiki

Best Holiday Spots of the World

Book 1 - When Considering a Cat

Book 2 - All about the Different Cats

Book 3 - General Caring for a Cat

Book 4 - Specific Cat Care

Candles

Caring for your Bird

Christmas Magic for Children

Dark Traveller

Frogs

Gardening is Fun

Horses

Loving Yourself

Meditation

Part of your World

Seal Island Adventure

The Different Ways of Celebrating Easter

The Guinea Pig

The Magic of Folly Meadow

Worlds of Ice

Table of Contents

1 The Interesting Historical Roots of Airbrush Artwork 8
2 Tips for Beginners in Airbrush Artwork 12
3 Paints to be Used for Airbrush Artwork 16
4 Types of Airbrushes Used for Airbrush Artwork 20
5 Understanding the Parts of Your Airbrushing Equipment 24
6 Taking Good Care of Your Airbrush 28
7 How to Prepare Various Surfaces for Airbrush Artwork 32
8 Creating Original Design Stencils for Airbrush Artwork 36
9 T-Shirts with Airbrush Artwork 40
10 Automotive Airbrush Artwork 44
11 Airbrush Artwork for Your Fingernails 48
12 Airbrush Art Tattoos 52
13 Instructions on How to Care for Airbrush Art Tattoos 56
14 Kits for Airbrush Art Tattoos 60
15 Getting Inspiration for Airbrush Artwork 64
16 Books to Learn the Art of Airbrushing: Beginners to Experts 68
17 Magazines Devoted to Airbrush Artwork 72
18 DVDs to Learn Advanced Techniques for Airbrush Artwork 76
19 Pamela Shanteau: An Expert in Airbrush Artwork 80
20 How to Gain Free Exposure for Your Airbrush Artwork 84
21 Why Airbrush Artwork Works for Everyone 88

1 The Interesting Historical Roots of Airbrush Artwork

A very popular art form has surfaced on many surfaces; paintings are found everywhere there is an open space. We can find airbrush artworks on clothing, skin, canvas, wooden structures, automobiles and even public structures such as bridges. Building murals and motorcycles are now also good targets for artists to demonstrate their creative airbrush paintings.

The origins of the art of airbrush painting are just as fascinating as the artists' creative designs. It is believed that a primitive type of art done by airbrush painting existed in some ancient cultures. Perhaps a small hollow bone was used to spray the paint simply by blowing your breathe through the bone? This method would push the paint through the bone to result in a fine mist of paint. Although this method may seem quite primitive when we compare it with more modern versions of airbrush artwork, it still produces an airbrush image. There are simple art kits for children based upon using a plastic tube; the child blows through the end of the tube to produce the mist of paint. These ancient art forms have guided

airbrush art activities useful to children's crafts of today.

The world saw a newer version of airbrush artwork in 1893; Charles Burdick sought a patent for his airbrush device which was used to retouch photographs up until the 1920s. The use of the airbrush technique increased in the 1930s. The advertisement agencies found the technique ideal for creating advertisements of their many new products. Airbrushing was soon used for painting Pin-Up Girls on World War II American airplanes. The world of the fine arts took notice of the airbrush technique when practicing artists saw the painted images on the airplanes heading out to defend their country.

By the 1940s, Walt Disney became interested in what he could do with this technique. He introduced an entire new way to use airbrush images by bringing the art form to the movie screen as animation. The complicated backgrounds in the Walt Disney animated films were made by using airbrushing. The technique allowed the Disney artists to create lighting tricks and shadows for a much more realistic background scene. Even the Disney work seems quite simple compared to current animated movies and contemporary airbrush artwork, but his

methods paved the way for improvements in both techniques.

By the 1960s, the airbrush techniques developed were much closer to our current understanding of how the technique can be used. In the 1960s, examples of airbrush art were found in the world of music. The album covers created for the hippy style music used airbrush artwork to make the wild psychedelic images that were popular for that era. Do you recall the tie-dyed clothing, the large floral designs or the bright neon colored peace signs that made their way even onto the sides of vehicles? Airbrushing saved an enormous amount of time in getting the art images painted on the vehicles.

The use of the airbrush technique has developed continuously since its origins as a primitive means of expression among our ancestors. It gained popularity first through the changing techniques of photography and was then picked up by the advertising companies. Album covers were enhanced with bright swirling airbrush designs and once Walt Disney realized what a tremendous aide to animation airbrush painting could become, his movies became magical. By now we see some type of airbrush artwork on almost every surface around us in daily life. The limits for airbrush art work by

now rests in the minds of individual artists, producers, directors and advertisers.

2 Tips for Beginners in Airbrush Artwork

Learning new techniques is always challenging. With airbrush artwork you are trying out a brand new type of art, so your first attempts at airbrushing may seem slow to master. Of course, the experts teaching you the techniques on videos will make every move seem so easy, and you will then be surprised that none of it seems easy to you. You will need to begin by practicing the simplest technical steps over and over until you can do them easily. Mastering simple techniques can give you the better understanding of airbrushing processes which will allow you to build a foundation that can be used as the basis for more difficult techniques.

A good way to try out an airbrush is to use an inexpensive flat surface and black paint. You do not need to spend a lot of money to get started, so buying additional colors can wait until you get some practice. You will need to experiment with basics to master the process of airbrush painting; just get yourself used to how the airbrush feels and how it works in your hands. Practice your spraying technique by controlling the airbrush spray on a cheap surface to learn how to adjust the

airbrush pressure for the effect that you want. If you have the double action type airbrush, you will need to experiment with distance to learn how far back to stand from the surface to achieve a certain effect.

Once you become comfortable in using your airbrush, the next step is to practice creating different types of shapes using the airbrush. Practice making airbrushed geometric shapes: triangles, circles, squares and rectangles. This may sound pretty simple but it is really not; the continued practice will teach you to learn exactly how to create those useful designs by mastering your airbrush. Continue practicing these basic shapes until you master them and can produce perfectly even geometric airbrushed shapes. Once you perfect your ability to render these basic shapes, you can then move on with using different textures in the shapes. You should also work on airbrushing shapes using thin lines and then some shapes using thick lines, which will teach you to master the use of the airbrush to create some broad designs and also make fine details.

Once you master creating the basic shapes, you should try using the design stencils. Almost all beginning airbrush artists make use of design stencils in

order to create their style of airbrush artwork. Try practicing the stencils still using the inexpensive surface and black airbrush paint. Only the practice will train you in how to use the stencils to get your desired effects and also how to carefully remove the stencils from the surface without disturbing your painted design.

Golden Airbrush Colors is an ideal type of paint for a beginning artist to use for airbrush painting. This type of paint is sold absolutely ready to be used "as is" and will save you lots of trouble having to learn how to deal with paint thinners and all those thinning issues. You can begin to use more complicated types of paint once you have practiced and learned from some experiences with the airbrushed artwork. Keep using the ready to use simple black paint by Golden Airbrush Colors since it certainly doesn't matter how your paint finish looks at this point in your process. The simple thing that does matter is learning basic techniques to give you a solid base of skills with which to advance forward.

3 Paints to be Used for Airbrush Artwork

Many different types of paint will work well for making airbrush artwork. It really depends upon which surface you are airbrushing the paint onto since some paints are designed for certain surfaces only. Some of these paints are unsafe to use on special surfaces so be sure you are aware of the specific requirements for using the paint you select safely.

If you are airbrushing paint onto metal, plastic, ceramics, vinyl, cloth, or wood you should use acrylic paints that are water soluble. Therefore, the acrylic water soluble paints are the best paints for using on model airplanes or model cars. This type of paint also is the best choice of paint for airbrushing artwork onto t-shirts. Just be careful in using the acrylic paints because once they dry, they are very hard to remove.

Some of the acrylic paints are thick when you first squeeze them out of the tubes so you may need to thin the paint with water until it flows well in the airbrush. Some of the acrylic paints also need heat setting when used for designs on clothing. The heat set can be accomplished by placing some protective white cloth over the

painted design and ironing the cloth which sets the paint. Another way to heat set the paint is to turn the garment inside out, place it into the clothes dryer and turn the machine on the highest heat. If your acrylic paint does not describe that it needs any heat setting when used for fabrics, you should be careful to protect the airbrushed design from any fading when it is washed. This is very easy: just put the clothing to soak in the sink, fill the sink with cold, salty water and let it soak. Now you have taken all precautions and your originally designed clothing will be laundered with no risk of damages or fading to the airbrush artwork designs.

The type of airbrushed paint for the body artwork or for tattoos is sometimes described differently but it is actually the same paint. The paint is usually called paint for body art or it might be called ink for an airbrush tattoo. These two are basically the same material and they maintain the most realistic looking designs since the paint is long lasting and waterproof. If you decide to remove the design, you can either just wait since time will fade the tattoo or you can rub the designed area with some baby oil which will remove the design. If you want a long lasting design, you need to use talc powder and rub it into the design daily.

This powder will insure that the paint stays on the skin longer.

For airbrushing artwork onto fingernails, acrylic paint for fingernail art is needed which cleans up easily with water when it is still wet. If you happen to get any acrylic paint on your skin or on some other surface, just clean it up very quickly before it has a chance to dry since it will be permanent as soon as it dries. There so many fun possibilities when you are using acrylic paint for fingernail designs because you can mix colors to create a unique color of your own.

If you are planning an airbrush design for an automobile, you must use acrylic enamel paint. These paints are inexpensive and they do not clog the airbrush in the way that lacquer clog. Be sure to buy the mixed colors and also avoid tinting any colors, since the tints do not have paint driers. Just remember to select the exact paint needed for your project to get the most professional result.

4 Types of Airbrushes Used for Airbrush Artwork

Several different types of airbrushes are available; the one that you will want to use will always depend upon what you are trying to create. The different types of airbrushes all have certain options for various reasons; you need to make a study of the airbrushes available to you, consider your needs and then decide which ones work best for your projects. Let's first consider the options for how the paint is mixed and why this is important; your choices are an internal mix or external mix system.

An internal mix airbrush system mixes the paint and the air internally or inside of the airbrush. The part of the airbrush where the air and paint are mixed is called the head assembly. This process creates an atomized spray pattern of many fine dots of paint. Therefore, an internal mix airbrush is a most appropriate choice for any fine detailed type of work. An external mix airbrush mixes the air with the paint in the fluid assembly which is outside of the head assembly. These external mix airbrushes produce the large dot patterns of paint; therefore, larger areas are airbrushed more successfully using an

external mix system. The artist can definitely cover a much larger area in far less time by using the larger dot patterns.

Another choice to consider is whether to use a single action or dual action airbrush which refers specifically to how each airbrush functions. In a single action system, the trigger controls only the air. While the trigger controls the air, the exact amount of paint released is determined only by a needle adjustment found on the airbrush handle's back. A dual action system uses a trigger to control both the air and the paint; you press the airbrush trigger down to control the air and press it back to control the paint.

Airbrushes are available with three different types of feed: gravity feed, bottom feed and side feed. Which type of feed to choose depends upon what type of work you have at the moment as well as your comfort level with each different procedure. A gravity feed uses a top mounted cup that relies upon the force of gravity to pull paint downward into the airbrush. This particular feed works best for airbrushed artwork designs calling for fine detail since the gravity feed process uses much less air pressure. If less air pressure is required, slower movements can be used for very careful airbrushing.

A bottom feed airbrush has a cup mounted on the bottom; the paint comes up into the airbrush through a siphoning tube. Sometimes this design is simply called a siphon feed. An artist may prefer the bottom feed airbrush if several colors are needed for the design because the different cups of colors can easily and quickly be changed.

The side feed style airbrush uses a cup which can be mounted on the side and because the cup for side feeding can be rotated, it allows the artist to airbrush in either a horizontal or vertical direction. Many fine details can be created using both a side feed airbrush or the gravity feed airbrush. One advantage of a side feed model is that there is no paint cup to obscure your vision which is different from the gravity feed airbrush.

5 Understanding the Parts of Your Airbrushing Equipment

Every beginning airbrush artist needs to understand all the parts of the airbrushing equipment and what each part does. After all, how can you hope to create some really great airbrushed artwork if you have no understanding of the functions of the different airbrushing parts? So spend some time gaining your knowledge of each part of the airbrush; this well spent time will teach you how you should use the airbrush properly as well as how you should take the best care of it to extend its usefulness.

If you have the internal mix type airbrush then the equipment includes a needle which controls the flow of the paint. Damage to the needle causes very poor paint spray results and uncontrollable patterns. Therefore, it is really important to protect the needle from damage like getting bent. This will prevent you from having to either straighten or replace the needle which you do want to avoid.

The tip of your airbrush needle is covered by an air cap and the head assembly on the very front of the airbrush. The important purpose of these small parts is

in controlling the atomization of the spray of the paint. If any of the front parts happen to get damaged or dented in any way, then replace them with new parts immediately. Even minor damage to an air cap or to a head assembly can affect the proper performance for the airbrush. Just as a bent needle slow you down, a faulty part will cause the airbrush to lose correct action so you will be unable to continue creating quality airbrush artwork. The needles, air caps and head assemblies can all be purchased from many craft and hobby shops where quality, brand name airbrushing equipment and parts for airbrushes are sold.

The part of the equipment that allows you to operate the airbrush is called the trigger. In the single action type airbrush your trigger controls only an air flow. However, in the dual action type airbrush your trigger controls air flow and also the flow of the paint. Beginning airbrush artists need to practice and take their time to discover just how their trigger works.
This approach will allow them to perfect a technique and control their airbrushing. The airbrush equipment also has the back lever which shuts off any air flow as well as the paint flow once the trigger releases. If the back lever gets damaged, you might experience some serious problems when trying to operate the airbrush. But do not

worry about these problems since we are covering how to avoid damage as well as where to but replacement parts.

Every airbrush has some type of a handle that you should use to hold it properly. Different types and models of airbrushing equipment have either solid handles or handles with an opening. The opening is important because it allows you to adjust your needle in the single action type airbrush without having to take off the handle. Many more experienced airbrush artwork artists do actually take the time to remove the handle in order to deal with possible clogging issues on a routine basis. Therefore, you have a choice: do you think you want the handle to be on or off when you create your airbrush art?

Be careful to pay extra special attention to those threads on the head of the airbrush right where your air hose connects to the airbrush. If any of the threads happen to get cross-threaded, you could experience some air leaking. Any air leaking will affect the functioning of the airbrush adversely so just make certain that you are careful to avoid cross-threading in that area.

6 Taking Good Care of Your Airbrush

Taking very good care of the airbrush equipment is perhaps the most important things to know about in airbrush artwork to make your life easier. Keeping the airbrush equipment in fine, clean working order may save you not only money but also many hassles. Airbrushing equipment that stays unclean and improperly cared for will certainly break down more quickly and will function poorly as well. Also, if your equipment is improperly cared for and unclean it will not be able to produce the fine quality airbrush artwork that you are looking to create.

The first step is to learn exactly how you need to clean airbrush equipment. The exact type of airbrush cleaner that you use depends completely on which exact type of paint is used in the airbrush. Therefore, the paints that are solvent-based must be well cleaned using a quality cleaner that is solvent-based. All of the paints that are water-based must, of course, be cleaned using water or another commercial cleaner especially designed for airbrush cleaning. Windex is always useful when cleaning the airbrush equipment between changing colors when you are using the airbrush. But never soak the

airbrush or it exposed to the Windex for a very long period. You do not really need to take the airbrush completely apart every single night for cleaning; it is usually fine to completely break the airbrush apart once each month. Be very careful that you remember to use the cleaner for only a brief time. The very next morning, you must use your special brush for airbrush cleaning to clean it. Finally, make sure to remember to oil the airbrush well before you put all the parts back together.

Many airbrush artists have found that if they use their airbrushes with the cap of the needle removed, this permits them to have more control. If you remove the needle cap, that is fine yet, if you happen to hit the airbrush solidly against something or drop it, the needle could become damaged. So take very excellent care of the airbrushing equipment, be certain you put the cap back on the needle when you are finished using the airbrush. This action gives some protection for the delicate needle just in case the airbrush happens to fall or bump into a hard surface. A damaged needle would be a disaster for your chances to produce your high quality airbrush artwork. If you cannot manage to straighten the bent needle or if it breaks completely, you will be unable to do any more airbrush artwork until you find a replacement

needle. If you do experience some bad luck and you do happen to bend your needle, a pair of pliers may straighten it for you. Just place the needle tip into the pliers, and then gently try to straighten it but do this very gently so you avoid breaking the needle.

If you take excellent care of the airbrush artwork equipment, it should last a long time. Just use the proper cleaning solvents faithfully one time each month, do the full break down carefully and clean each part completely well. Most artists have noticed that needles made in China tend to bend more easily so find needles made in other countries; you really do not want to try to straighten a bent airbrush needle if you can avoid it. Also keep in mind that all the best airbrush equipment to use and the easiest to care for is quality brand name airbrush equipment. So look for the better brands for all your needed supplies and parts since the inexpensive knockoff ones are certain to break much more easily.

7 How to Prepare Various Surfaces for Airbrush Artwork

You always need to prepare your surface before you start airbrushing; it does not really matter what surface you are using. Your choice of a surface determines the type of preparation that is required. All this preparation work ensures that your painted design sticks well to the particular surface for you.

If you want to airbrush onto fabrics such as denim, t-shirt fabrics, sweatshirts and even other all natural fibers, first you must thoroughly wash the clothing or material. The washing will take away any loose fibers and shrink the material. If the material shrinks after design is painted on, your creative work will be ruined.

Even a surface like leather needs cleaning with rubbing alcohol before any airbrushed designs are placed on it. The alcohol will remove any oil on the surface of leather; leather is often oiled to preserve and protect it. The presence of oil can interfere and act as a preventive so the paint is unable to stick to the surface of the leather. So just make sure all leather areas have been cleaned well with the alcohol and that the leather is completely

dry before you begin working on your designs. Paint a coat of opaque white paint onto the leather and let it dry before beginning the airbrushing. This white base coat will allow the colors to be bright and true.

All surfaces made of wood need to be sanded down in preparation for any airbrush artwork. Use a piece of fine sand paper to sand the wood lightly by hand. Use the floor hand sander if you are planning to make an airbrushed mural for a wooden floor. Sand carefully so you do not scratch or mar the wood; just remove the rough areas. If the wooden floor has a glossy coat or has a waxed surface then the sanding will remove it which allows the paint a chance to stick well to the wooden surface.

Human skin needs to be well cleaned by rubbing it with alcohol which removes the oils. Our skin has its natural oils that prevent any airbrush ink or paint from sticking well to our skin. These oils can cause your airbrushed artwork tattoo to wear off too soon. Using talc powder once the fresh design has thoroughly dried helps keep the oil from accumulating again which will ruin your new airbrushed tattoo.

All fingernails must be extremely clean and well buffed before beginning any airbrush nail art. The buffing gives the fingernails a rougher type of outer surface which is good for the paint so it can cling tightly to the nail. Before the fingernails actually get any airbrushing, a strong base coat of paint needs to be applied. The two reasons to apply the base coat are for protection of the nail and to make the paint adhere better.

Metal surfaces need to be wet sanded until they have a grainy, rough effect on the surface which will help with adherence of the paint. Since the metal is naturally so smooth, any airbrush paint may not stick easily. After the metal is wet sanded the base coat needs to be applied prior to any airbrush artwork design.

Just be careful to take all your time making certain the surface you want to work on is carefully and thoroughly prepared in order for the airbrush paint to have a chance to stick well. There is no reason to get working on a new and interesting airbrush artwork design just to later realize that your paint is not sticking or it looks poor.

8 Creating Original Design Stencils for Airbrush Artwork

There are basically two approaches to creating airbrush art work: using stencils or making a freehand design. Most of the stencils or masks that you can purchase are reusable products which will be a help to your expenses. The various stencils are made of several different materials depending upon what paints or inks will be used with it. If you rely on stencils that are available commercially, you will be limited in your creativity. These standard stencils can certainly assist you with making airbrushed artwork but the designs are not personal. The very best solution to creating original and personally creative art is to make your own stencils or try freehand airbrushing without using stencils.

You do not need to know how to draw to make yourself some original stencils; if you can just carefully trace a design, you will be able to make yourself some original stencils inexpensively. You can simply find any type of design that pleases you and trace over it using thin paper. Next, make yourself several copies of your design since the design papers will get used up during the cutting process and the

airbrushed paint will get the stencils wet so they often begin to tear. Make sure you keep your original traced design to refer to and reuse to make more copies of the design. After you have several copies of the traced design, begin cutting away the areas of the design that will become the open spaces for the paint. You are now ready to place your hand made design stencil onto the project and begin the airbrushing process.

If you would like to try using more durable materials for creating your handmade stencils, you might like to try using the plastic of plastic pocket folders. These folders can be purchased rather inexpensively from office supply stores or any store that sells standard school supplies. An exacto knife is best to use for cutting the plastic. Depending upon the total size of your design you might be able to create two or more stencils from just one plastic folder. If you can find see through plastic folders you could use those very nicely for stencils; just draw the design directly onto the clear plastic.

It does not really matter what exact material you use to make the stencils but remember to cut around the areas that will remain open very slowly. By taking lots of time you will make certain that all the different shapes match up the way

they should. For example, if you are making a stencil to produce the shape of a dog, then you must take plenty of time to make sure the eye shapes are the same sizes, the nostrils of the nose are carefully cut out and shaped in a natural way and so forth. Rushing will result in an unconvincing image so then you end up with a mess and a wasted useless stencil.

The stencil is your aid in creating your personal airbrushed art work so it is a large part of the creative process. Unless you want to master free hand designs, you need to become very proficient at making your own stencils. If you are having trouble making good stencils, then spend some time practicing with scrap pieces of plastic material until you get used to how an exacto knife works and just how to use it to properly cut away the unneeded areas of plastic. This extra practice time will help you to ensure that you are creating a reusable working stencil to create original airbrush art.

9 T-Shirts with Airbrush Artwork

Decorating T-shirts with airbrush artwork is a really creative and fun hobby. It can also be an exciting and fun business venture for anyone who wants to give it a good try. These T-shirts decorated with airbrush artwork are unique and quite popular to wear. The original "one of a kind" image on each shirt gives the owner of the shirt something that no other person has to wear.

To create unique airbrush artwork does not require one to learn how to draw well. The stencils and the airbrush are the keys to this art form. If you learn how to master the use of your stencils and how to finely control the airbrush you will succeed. The biggest challenge is in learning the control of the airbrush gun in order to spray the paint exactly where you plan for it to be in the designs. It is a bit difficult to avoid any over spraying with the airbrush paint so that it does not go anywhere that will be a problem. Once you have mastered this technique, your options are probably endless as far as creating designs due to the vast selection of stencils you can buy.

The best airbrush to use for T-shirt designs is a siphon feed or bottom-feed

airbrush. And always try very hard to purchase the most reliable brand name airbrush when you are ready to do your airbrushing. Badger and Iwata remain the most trusted brand names brands but Paasche is a fine quality airbrush also. Using an off-brand or generic airbrush will probably cost you more money over time.

As far as buying your airbrush compressor goes, just know that a high PSI is needed to airbrush the artwork onto the T-shirts. The PSI setting for this work need to be should be between PSI 40 to 60. Always make sure your compressor is properly rated for exactly the type airbrush work that you are intending to create. If you decide to pursue this as a business venture, then you need to invest some money into buying an air compressor that is of commercial grade.

For most of your airbrush designs, you need to heat set the painted areas to allow washing without any bleeding or fading of colors. There are different ways to do the heat setting process. One simple way to heat set is to allow the design to dry completely, put a clean, white cloth over the design on the shirt and then iron the cloth and the t-shirt. Keep your iron constantly moving to avoid burning the material. An even easier way to heat set at your home is, after allowing your design to

dry completely, put the shirt in the clothes dryer after turning it inside out. Run your dryer for around 40 or 45 minutes at the highest possible heat setting so that the designs will be certain to hold up well to laundering.

Even if you use airbrush paint that requires no heat setting process you need to heat set the designs to be safe. You can do this most easily by putting the designed t-shirt into salty cold water but put just the shirt by itself. A great way to do this with paints that do not require heat setting is to place the t-shirt by itself into a sink full of cold water that has salt mixed into it.

Airbrushing artwork on t-shirts can definitely be exciting and fun but you are never limited to designing just t-shirts. You could get some creative ideas and airbrush some designs on underwear made of cotton for yourself and your significant other or maybe airbrush some cotton socks for your whole family.☐

10 Automotive Airbrush Artwork

You can have a paint job for your car that is completely unique and displays your certain type of style by using airbrush art on your vehicle. All you really need to know are the basic skills of the art and how to use the airbrush properly in order to create a one of a kind airbrush design. You do not need to know how to draw or paint well; it is totally unnecessary to be able to make a free hand drawing. You can do the airbrushing onto your car just like you can use stencils on any other project or surface. Only the imagination limits what you design using airbrush art. You can make stencils for yourself according to your original designs or you can buy stencils that match your ideas well.

Just do not try making the stencils out of paper if you decide to create the stencils yourself for your airbrush design.

Airbrushing on an automobile will need plenty of paint which would damage the paper stencils quite quickly. Use vinyl or plastic material to make your stencils. Using the thin plastic material that a plastic folder is made from works very well and those folders are relatively inexpensive. These plastic folders can be found in the office supply or stationary sections of many stores.

There are several different styles and types of airbrushes to choose among. A gravity fed type airbrush is the best one to use on a car and it is the same one that the professional artists use. Your airbrush art will have the most high quality finish by using the correct airbrush. You can use automotive paint but you must make certain to use a very well ventilated painting area since the fumes do pose a hazard to your health. The best practice is to wear a respirator when you are around the paint for automotive work and wear it all the time. Be careful to thin the paint enough with lacquer for automobiles to be certain that it will flow easily through your airbrush. Thin the paint down to a thickness similar to the thickness of milk. The paint should be thinned to about a milk thickness.

Different types of airbrush artwork call for using different psi settings to be set for your compressor. PSI means pounds per the square inch and for the automotive airbrush artwork you will need a compressor with a psi at 55-65. The brand of Iwata is the quality name brand that you should use and four different compressors are produced which will work well for airbrush automotive artwork. Badger is yet another fine brand to use if you can find it and several different air compressors are produced. Any of these

will work fine for the airbrush artwork on your automobile.

Be sure to use the same name brand for every part of your airbrush equipment including the airbrush, its different parts and the compressor. Do not try to substitute any knock off or copycat parts since these may cost you extra money and also lots of headaches for the long run. It is true that we get what we pay for so when for your airbrush art go with the trusted brand names you can trust best. Using knock off parts will also give you a harder time when you go to get replacement parts because they tear apart more quickly than name brand parts. Just save yourself a big headache; do not find yourself working on your airbrush project for your automobile and be unable to get the right replacement parts to fix your airbrush.

11 Airbrush Artwork for Your Fingernails

Doesn't every person love some type of art or design? Many women enjoy getting their fingernails manicured; we see our fingernails all the time so they should look good! So how about combining the manicure with an art to produce a new art form? Well, this is exactly the result; airbrush art has been combined with a manicure. This is a great opportunity for women to make use of their nails as miniature artworks. The airbrush designs applied to fingernails give a nice flare to any manicure. The types of designs are limited only to the artists' imaginations, the interests if the client and the stencils used.

This fun form of airbrush art work has gained popularity therefore and many hair and nail salons all over the world are offering the service for their clients. Airbrush artwork is available to you already painted on fake nails which are sold at many stores and salons that carry the fake nails. You too can join this fashion craze! You can learn how to do this craft, start your own enjoyable and artistic business of offering airbrush artwork on nails.

However, creating airbrush designs on fingernails is really not for a beginner who is just starting to master the airbrushing techniques. Your available work area is tiny...a fingernail... so the artist needs total control of the techniques. One major issue that beginners experience is the problem of over spraying the work area. You will not receive very much repeat business if you are working with nails and you end up with the airbrush paint on the person's fingers. So before you attempt to do any airbrush artwork on fingernails, practice and gain your experience by airbrushing some designs onto larger surfaces.

The type of airbrush equipment that you need always depends upon what type of airbrush artwork you are creating. Airbrush fingernail art turns out best when you use either the Iwata HP-A airbrush or the Iwata HP-B airbrush. These two are the best and give the finest images when airbrushing fingernails. Even if you are unable to use the favored Iwata model remember: go with a name brand product and stay away from copy-cat airbrushes.

You will also need a type of air compressor specially designed for working with airbrushing on fingernails. The very best compressor that you can use is an Iwata

Studios product called the Series Silver Jet Air Compressor. Even though this particular one is the most preferred and recommended one, you can go use any small compressor with an 18 PSI. If you are unable to get the Iwata Silver Jet, then get a different air compressor which has an adjustable 10-18 PSI.

You will also need fingernail art stencils or art masks for nails to do the airbrush art on fingernails. The fingernail art masks are small reusable masks with an adhesive on the back that leaves no residue on the fingernails. Of course, you can practice freehand airbrushing designs directly onto the fingernails and if you are successful, you will not need the stencils or masks.

If the direct application is not working for you, then invest in the fingernail art masks and stencils. A water base paint is used to create airbrush artwork on fingernails. You first apply a bottom coat of paint, then the design coat and finally a top coat of paint to protect the design layer from damage. You also spray a very light coat of varnish on between the design or artwork layer and the final top coat. Varnish is another water base clear coat to protect the design layer of paint from picking up any brush strokes as you apply your final top coat.

12 Airbrush Art Tattoos

A most fascinating and rewarding form of airbrushed art is creating airbrush tattoos. These beautiful painted tattoos are able to be painted anywhere on your body and they also last quite a bit longer than other temporary tattoos. The airbrushed tattoo can last for seven days while the other types of temporary tattoos wash off as you take a shower, bath or go swimming. Only a good period of time or using baby oil will remove the quality airbrushed tattoo. Also, the airbrushed tattoos look more realistic than the other types of temporary tattoos.

Henna can make an attractive temporary body design which lasts for a while. Lots of water and a good amount of time are needed to make the henna designs disappear. But henna does take a good amount of time to paint by hand on the body. The airbrushed art is quick to paint on which saves a lot of time as compared to the henna designs and the airbrushed art is also waterproof. Unlike the henna designs, even extended exposure to water would not fade your airbrushed tattoo. While an artist would need six hours in order to paint a sizable henna design, an airbrushed design could take just about

thirty minutes. This saves time for an artist and for the client who must remain sitting still throughout the process.

An airbrushed tattoo is safer for your health than a real tattoo. There is no risk of infection which might occur when the skin is pierced by the inking needles. There is also no time needed for healing when you get an airbrushed tattoo. The best part is that there is no pain. The real ink tattoos are created with painful work which is a major reason many people will not get one. Therefore, using airbrushed art tattoos gives many people a chance to enjoy having a realistic tattoo without experiencing pain.

A real tattoo is permanent so will be stuck with whatever design you get for a very long time. If you decide that you don't like the tattoo, you will need to cover it up or undergo laser surgery which will remove it. The airbrushed tattoos can be removed by using baby oil or you can wait around seven days for it to fade away. There is no reason to get a bigger tattoo in order to cover an offending design or to endure laser surgery.

There are a few supplies needed to make airbrushed tattoos: one airbrush gun, ten feet of braided hoses, design stencils, glass bottles for airbrushing and one air

manifold. Of course, you also will require some airbrush paints specially designed for use on human skin which are called tattoo inks for airbrushing. Finally, you also will need seventy percent alcohol and some talc powder. Many airbrush stencils are available with a wide choice of designs to give you unlimited creative choices when making airbrushed tattoos. Talc powder is applied over the tattoo once it has dried to help maintain the tattoo and keep it from fading. The alcohol is needed to clean out the airbrushing gun and the glass bottles when you are finished.

The airbrushed art tattoos usually last for seven days. If you happen to have very oily skin, your tattoo might begin to fade in just a few days. Dry skin holds the tattoo longer than the seven days. An airbrushed art tattoo will last as long as possible if you can keep applying the talc powder frequently. When you have decided that you are ready to remove the tattoo, rub it with baby oil to rub it off.

13 Instructions on How to Care for Airbrush Art Tattoos

In order to make sure that the tattoo inks stick to the skin and prevent it from fading away, one must take some precautions in advance. If this preparatory work is properly done and the customer is instructed well regarding the home care instructions one can expect many days of enjoying some realistic artwork decorating their body. Considering the amount of time and the cost for creating such great realistic looking airbrushed artistic tattoos, one is not expecting it to look faded within just a couple days' time.

While many experienced airbrush artists may already know this information, a beginner of the art may be unaware, so the details are worth mentioning. When painting airbrush artwork onto skin, make certain that you are using the exact airbrush paint designed for usage on the skin. Usually this tattoo ink is sold labeled airbrush body paints or perhaps airbrushing temporary ink for tattoos. These paints or inks are the only safe types to use directly on the human skin.

Oily skin is a bit more difficult for tattoo inks to adhere to well. A competent tattoo

artist uses alcohol to rub onto a person's skin which kills germs and removes the oil prior starting tattoo process. An airbrushed tattoo will stay on the skin longer if skin oil is removed; this also gives the colors a chance to be more vibrant since they are not diluted by any excess skin oil.

Now that the skin is cleaned, one can begin to airbrush on a tattoo design. One still must take lots of time, being very careful of every step you are doing and how technically you are executing it. There is absolutely no room for any mistakes when making airbrushed tattoos on someone's skin. Just take all the time you need, do not let anyone or anything rush you to ensure that you do not make an unfortunate mistake for a person who trusted you with airbrushing a design on their skin. While all very experienced artists certainly understand this problem well, any beginner at the art form may just not realize the importance of the care needed.

Once the new airbrushed art tattoo has absolutely dried well, then you will need to immediately apply some talc powder. This talc powder is important because it will be very helpful in absorbing any remaining oils which ensures a longer life for this new tattoo. All correctly prepared and well

airbrushed tattoos should last at least seven days but a person with very oily skin might only be able to expect their tattoo to last for around two days. Therefore, an honest airbrush artist needs to tell their customers with oily type skin the importance of applying the talc powder for themselves at least several times each and every day to help them get the most enjoyment from the new tattoo. Most people who have dry skin can expect to enjoy their tattoo for more than seven days' time. But it does not really matter whether people have oily or dry skin if they remember to apply the talc powder faithfully once the airbrushed art tattoo dries well.

Airbrushed tattoos certainly do cost plenty of money; customers are unwilling to spend their money if the tattoo will not last the expected amount of time. So just make very sure that you follow all pre as well as post steps in order to ensure the most realistic tattoo. Try creating a new care sheet for the customers to make sure they know exactly how to care for the new tattoo.

14 Kits for Airbrush Art Tattoos

Temporary tattoos can be made from airbrushing. They are exciting and really fun to make, they last quite a while longer than most other types of temporary tattoos and have a more real look. Unlike tattoos made from henna which must be painted on by hand, airbrushed tattoos only take a small amount of time to create.

If you purchase a kit for making airbrushed tattoos you will have all the necessary items to get a good result. The tattoo kits are available in many different sizes and at different prices depending upon which dealer you contact. Try to find a quality product and do not be swayed by the lower price kits offered by lower grade brands. The lower grade brands are no deal at any price so you are paying for failure if you get convinced that the low price is good enough.

One fine starter kit for tattoos is produced by a company called Airbrush Bodyart. This kit has everything anyone needs for starting to create airbrushed art tattoos plus some extra materials. The starter kit includes two ABA airbrushes which are single action airbrushes, two hoses, nine glass bottles for airbrushing, an air

manifold which has two outlets, seven tattoo inks which are sixty ml airbrush tattoo inks in white, yellow, red, blue, green, violet, fuchsia as well as one hundred twenty ml of black. Also included are fifty Vynalaser brand stencils which you can use again and again. The price for this kit is usually around $293, but if you bought all the items individually, you would probably pay close to $346.

If you have been practicing your skills and want to include more sophisticated designs, Airbrush Bodyart also offers a more professional type of kit. This one includes a larger air manifold with four outlets, four ABA airbrushes with single action, twelve glass bottles, four air hoses, ten sixty ml inks in white, yellow, fluorescent yellow, red, blue, fluorescent blue, green, fluorescent green, violet, fuchsia, and one hundred twenty ml of black. Also included is a one hundred twenty gram glitter pack which is holographic and one hundred reusable Vynalaser stencils. This kit usually costs about $544 but if you purchased the items separately, they would probably cost you about $639.

If you have become quite accomplished in this art form and decide to open a business, Airbrush Bodyart sells a professional level kit named Airbrush

Volume Parlor Kit, 2000. This larger set of materials supplies you with everything needed to set up your shop and offer professional airbrushed art tattoos.

This 2000 Kit includes the four outlet type air manifold, a four duel action siphon feed kit by ABA, four glass bottles, one airbrush holder, one moisture trap regulator filter, ten sixty ml tattoo inks in white, yellow, fluorescent yellow, red, blue, fluorescent blue, green, fluorescent green, violet, and fuchsia and one five hundred ml of black ink. Also included are a one hundred twenty gm jar filled with holographic glitter, three hundred Vynalaser brand reusable stencils plus a CD-Rom to show your customers Flash displays. If you bought the items separately, they would cost about $1,242 but this kit will be about $994.

Therefore, it will be much wiser economically to use a kit for getting started with airbrushed art tattoos. Of course, after you begin the business, you will need to replace items as you use them up but this is a small expense compared to the initial startup. A quality brand kit is your best way to get going in professional style for tattoos!!

15 Getting Inspiration for Airbrush Artwork

Sometimes the mind just goes completely blank when one tries to think of an interesting design to use for airbrushing. You really can find yourself without any ideas to use for an assigned project or even for your own personal expression. While the airbrush techniques can offer endless possibilities and effects through the paints and inks, the ideas and designs have to come from the artist. You have to have something to say through your artwork and finding some inspiration could come from a number of places.

Sometimes it helps to just begin by looking around wherever you happen to be, especially if you have changed your scenery. Try this idea and then look all around the new surroundings with curious, open eyes. Your inspiration may fade if you are cooped up inside an artist's studio for too long; get outside to a park, get some fresh air and take in the sights around you. Try to derive some inspiration from the various scenes around you now. You may see two young children playing on a seesaw in the park; could you turn them into two angels sitting on a seesaw cloud in up the sky? You might see some

children playing ball; they could become angels who are playing with a cloud. All of this could be combined into one airbrush art design. Do you follow my ideas? You can just take ideas from whatever is around you, transform those into something different and end up with a quite unusual floating cloud playground full of angel children.

Your inspiration can always come from browsing through some books. Stop by your library to check out a few books about art to inspire you and get your creative design ideas going again. Sometimes looking at some other people's art works you move your mind past a creative block which starts the ideas flowing for your original airbrush artwork again. Any art form can bring some ideas to you for airbrushing because any type of design lends itself well to the techniques of the airbrush. Spend some looking at examples of art that you enjoy in those books and then picture the same art as airbrush artworks. Think about how you could have airbrushed that same image; next, continue by making a drawing of how you see the design as an airbrushed piece. Once you feel happy and see the design as your own, then airbrush your new project.

If the outdoors is not the place you want to be and you cannot get to a library, there is always the world-wide web to surf. The entire internet is full of different images for inspiration that can be used for airbrush artwork. You could search for favorite artists, art styles, stock images or photographs. Just keep looking at the various images, keep up the surfing until an image comes along that gets your creative ideas flowing freely once again. You better print out your favorite image and keep it around you for continuous reference. There is an unlimited amount of material online for your inspiration.

Once in a while everyone needs take a big breath and step away from work to become re-inspired. Take just a few hours off and do something else that you enjoy, like taking a walk or watching a movie to let your mind rest. Your inspiration will return quickly, the creative ideas will begin again if you know enough to take a break for yourself.

16 Books to Learn the Art of Airbrushing: Beginners to Experts

If you want to learn all about airbrushing by yourself, reading some books can bring you all the basic information that you need. There are many excellent publications to teach you from a basic beginner level of airbrush artwork through the most advanced or expert level. These books are designed to teach the airbrush artwork techniques so they could be used alone or with other informational airbrush videos and magazines. The following several books offer good coverage on all levels of information about airbrushing techniques.

Airbrush written by Parramon's Team would be an excellent book to begin with if you are just starting to learn the techniques. This book describes everything about different types of airbrushes and all the various uses of these airbrushes. There are also detailed instructions included in this descriptive book on exactly how to handle each airbrush. Therefore a beginner who lacks any previous knowledge will make excellent use of the book. It will definitely help you to understand all the different

airbrushes that will be used while you create your airbrush artwork.

The book *Getting Started in Airbrush* written by David Miller is another great book for the beginner looking for information about airbrushing. This book gives you clear step-by-step instructions about the beginning level of airbrush artwork technique as well as instructions on how to make all the different design effects. This book will also help you to learn about the different equipment needed and other materials necessary that you use to create your artwork. Some of the design effects you will read and learn about include: lettering, freehand designs, effects to create different edges, highlights and even other interesting special effects.

Another introductory book is *How to Airbrush T-shirts and Other Clothing* by Diana Martin is a good one for beginners learn from or it can be used by a more experienced airbrush artist interested in learning techniques needed for airbrushing textiles. This book has loads of information about all the different equipment, assorted materials and exact techniques that you need to create fine airbrushed art directly on different textiles. The eighteen step-by-step instructional guides included in the book will put you quickly on the way to begin

showing off some of your best work on various pieces of clothing.

Professional Airbrush Techniques written by Vince Goodeve can teach some very pretty and intricate designs. The book will teach you to properly prepare any metal surface in order to begin learning or advancing in airbrush artwork on cars and motorcycles. While this book does teach some very intricate designs, you do not need to worry because it also explains some very simple projects to start with when you want to work on airbrushing for cars and motorcycles.

For anyone at the intermediate level of airbrushing art can learn a lot from *The Ultimate Airbrush Handbook* written by Pamela Shanteau. This is a book that can show anyone everything about airbrush artwork ranging from t-shirts to interior home goods. Almost every possible surface for airbrush artwork is covered at an intermediate level by Pamela Shanteau in her book. Whether you are airbrushing nails or airbrushing artwork onto cars, everything is explained in perfect detail.

Airbrush 2: Concepts for the Advanced Artist written by Radu Vero can help teach an advanced airbrush artist the more difficult advanced techniques. Learning these more advanced techniques helps the

artist to start creating even more complicated airbrush artwork. In a world of artwork, one needs room to always learn more technical skills to advance ways of working which will create an entirely new aspect of the current art form.

17 Magazines Devoted to Airbrush Artwork

Most art forms have publications designed to assist the artists and organizations devoted to the art and the art form of Airbrush Painting is no different. A quite diverse group of magazines is published that holds appeal for the airbrush artists. Some of these magazines can be found as publications in print and there are some found only online as well. Whether you prefer reading to learn about airbrush techniques in a magazine held in your hands or using an online magazine, you can gain much useful knowledge about the art industry of airbrush artwork. Some airbrush artwork is made as fine art like paintings on canvas; examples of this type of airbrush art can be studied in magazines. Other types of airbrush artwork can be found in magazines about airbrush painting for cars, bicycles or motorcycles. This variety in types of magazines provides more precise content for each specific niche of airbrush painting.

Airbrush Technique Magazine is one magazine covering a broad spectrum of airbrush art techniques designed to teach the general techniques. Therefore, this

magazine will be always useful; it does not matter exactly what surface you happen to be airbrushing. This publication is a subscription based magazine which can be obtained with a subscription for either one year or two years. It is a useful magazine if you just want to learn more general knowledge about airbrush techniques. It will be helpful whether you use airbrushing for your hobby or pursue the art professionally. *Airbrush Technique Magazine* comprises a wide variety of surfaces on which to paint. These include but are not limited to the human body, simple t-shirts, many types of canvas, automobiles, motorcycles and more.

Airbrush Artist Magazine is another broad spectrum magazine but it is an online magazine based on membership. This online publication offers many articles, videos and tutorials designed to guide you as you learn more information about the art form. It offers you unlimited access through membership. *Airbrush Artist Magazine* gets updated each month in an aim to offer at least two new articles, lessons and tutorials every month of the year.

The publication *Art Scene International* was formerly titled *Airbrush Art + Action*; it is based in Europe as an art magazine dedicated to airbrush art. This magazine

is now being sold also in North America and while it does have many people interested in the art of digital imaging following it, this magazine is a great asset for any type of airbrush artist. This magazine uses full color examples, many interesting artist's stories as well as "how to" articles of very practical use for any type of airbrush artist.

The magazine *Air Brush Action* seems to cover one specific niche of airbrush art work for each new publication. While each monthly issue usually includes several different types of airbrush art work, the issue for each month follows one main theme over all. This particular publication contains guides for buyers to help decide which materials to use, some tricks and tips of the trade, artists' biographies and more information which would be most appreciated by all airbrush artists. This magazine has a general appeal to many readers since it offers a monthly major theme.

If your interest is airbrushing for automobiles, then by getting a copy of an *Air Brush Action* automotive themed issue, you will be certain to have lots of information on automotive airbrushing. You must really keep checking monthly to see what the major theme will be so you are aware of when your particular style

will be covered in depth. Otherwise, you may be disappointed to find just a mention or two in your magazine regarding your particular interest.

18 DVDs to Learn Advanced Techniques for Airbrush Artwork

It is easy to progress in learning advanced airbrush techniques once the basic techniques are mastered. Your art will be more imaginative and masterful by using the more advanced techniques. You are lucky because there are many videos to help you learn the more advanced techniques for airbrush artwork. If you have a very specific design in mind, there are videos to teach you learn a proper approach to render that certain design to fit the art you are creating.

Creating Killer Dragons is an example of one of these specific videos produced by the *AirBrush Action Magazine* featuring the master artist of airbrush, Crossed Eyed. Crossed Eyed teaches you to create an airbrushed dragon and shows you every essential technique that is involved to render all the aspects of a dragon.

The video *Killer Klown* by Javier Soto can show you exactly how to paint an airbrushed clown. This particular video demonstrates just how to paint the strange but popular style of psycho-demented clown. This style of clown seems very favored for a custom paint job and if

you are interested in learning to create a clown of this style, this might be the video you need. Javier Soto deals with how to use textures, bright colors, highlighting and kandies to create a wonderful, brilliant psycho style clown.

The video *Kustom Pinstriping* which features the airbrush artist named Craig Fraser can instruct you in every aspect of pin striping. The video shows you absolutely everything needed for comprehending the technique of pin striping to move you to a professional level of pin striping. By learning from the video you will learn all the details of application and design, different kinds of airbrushes to use for the pin striping as well as which brush works best for each exact job. You will learn how to choose the paints and the other materials needed for this work. The practice exercises introduced will guide you to practice the techniques that you watch in the video and then you can work on mastering your skills.

The video *Biker Skull* which features the renowned Robert Benedict, a master airbrush artist, can take you very step-by-step through how you can create one very professionally designed skull on a cap made of leather. This particular demonstrate a very advanced level of detail. This is an unusual video since

these methods have never been put on video before this time period. If you learn from this exact video you will certainly learn exactly what you will need in order to have your special edge that makes you different from many of the other popular airbrush artists.

Using airbrush artwork creates excellent caricatures and there are many caricatures used in different types of artwork. The artist Kent Lind can introduce you techniques to help you create many cool caricatures. This is approximately seventy minutes of a video titled which is *How to Airbrush Caricatures*. The video goes over all of the details needed to know how to make your caricatures in airbrush art. The airbrush designs are always great looking on canvas, t-shirts and if a very bold statement is what you want the most, you can have one painted on your vehicle.

After all, isn't art all about the imagination, showing your best creative ideas? If you advance your techniques then learn new methods of design, it can only help you improve your art.

Once you have the advanced techniques learned and master the design styles covered in the articles, you will be able to customize the information to create some original art.

19 Pamela Shanteau: An Expert in Airbrush Artwork

The renowned artist, Pamela Shanteau, has a talent for airbrush artwork that just spans over multiple surfaces using many different styles. Her fellow peers and enthusiasts for airbrush work recognize her highly customized airbrush artwork. She chooses the body, motorcycles and automobiles for her surfaces. Her work on motorcycles has earned her a position within the ranks of famous airbrush artists who create custom work.

Pamela's airbrush artwork was featured in the RM 2006, the 2006 Iwata and also the Paint Calendars of 2007. Both Harley Davidson Calendars for 2006 and 2007 featured her artwork. However, even if these Harley calendars illustrate her considerable talent extremely well, these calendars are definitely not the only location for examining the work of this particularly accomplished artist.

Popular magazines including Autographics, Hot Rod, Easy Rider, Airbrush Action and Mini-Truckin include and even feature Pamela's artwork. And she not only creates brilliant artwork in her airbrush paintings, she also teaches

many other people how to achieve the exact level of highest quality airbrush artwork that she creates. She released her book called "The Ultimate Airbrush Handbook" in February 2002. In the handbook she outlines all basics to airbrush artwork, the different airbrush types as well as exactly how one might organize their personal airbrush workshop. This book describes various styles of airbrushing including work on fingernails, on automobiles, t-shirts and even on leather. Shanteau had another book published in July 2007 to further help airbrush artists perfect their art. "Custom Automotive & Motorcycle Airbrushing" teaches her techniques that no one has ever seen. She shares her exclusive techniques that she personally created with all of the readers and artists who buy the publications. These few publications are really just a small sample of the many publications featuring Pamela's fine work.

Pamela also offers VHS and DVD tapes in order to help learn the art creating airbrush artwork on motorcycles and automobiles. These helpful videos will show you a step by step approach on exactly how to best perform certain techniques that will create a specific look. The series includes how to create airbrushed flames, some techniques for

making murals, specific masking techniques and how to airbrush the motorcycle gas tank area well. If you enjoy learning from visual instruction, the videos may be a better learning source for you rather than reading all her detailed directions in the books.

Pamela Shanteau's workshops also give developing artists a valuable "hands on" chance to try airbrush techniques. She offers these workshops many places throughout the United States. The students who take her workshops benefit from her personal supervision while building their knowledge base and expanding their range of techniques. Shanteau will personally demonstrate to show anyone the exact airbrush art techniques they want to learn, help them to quickly recognize their mistakes and then learn the best way to advance their techniques to a further level.

Any chance to learn the art form from Shanteau herself would be invaluable to an aspiring artist whether a rank beginner or very advanced. She is a most truly gifted artist with the finest airbrush techniques. Since her techniques and her styles are unique, the act of openly offering other artists a chance to learn them is remarkable. If someone truly wants to learn about airbrush artwork

from a best resource, here is the way to do it right. And Pamela has provided artists with several different mediums to study: calendars, magazines, books, DVDs and VHS tapes and workshops, from which they can learn her own distinctive style.

20 How to Gain Free Exposure for Your Airbrush Artwork

Getting yourself known and having your name recognized in any field always takes time and effort but a key element is to get your creative work out in the public eye and where people can become familiar with it. How can you build up a reputation unless there are people seeing, admiring and discussing your art work? There are some ways that will cost nothing or very little for you to get your creative work seen by people. You can most easily display your work to people all over the world by using the internet and it is free of charge.

Many people who use the internet also have a blog so why not try that to showcase your airbrush artwork? Set up a blog for free, start showing what kind of art you can do and post some examples of your work. Speak to the people; be sure to really talk with your audience, tell all about you and your strong passion for creating airbrush artwork. Put up good quality pictures to display your work and then explain to the audience exactly how you planned and created each design. Also explain all about the different paints or inks you used, the various types of airbrushes you prefer and any extra

details. By carefully discussing your personal techniques and also sharing your insights you will be showing your people your place in the world as an artist who knows the craft well.

Once you get some posts up to tell all about yourself and your excellent work then you will be ready to have your own blog sent to the entire world. Some blog sites such as Shout Post and Tblog actually show your blog posts off for you to other bloggers. This helps to get your blog some traffic. If you choose a blog host that does not do that then you should look into some blog traffic exchanges. After all what good is the blog if no one is seeing it? So find a couple of blog traffic exchanges and register your blog. A good traffic exchange if Blog Explosion. This exchange allows you to not only surf other blogs for traffic but lets you put your blog in the Battle of the Blogs for a chance to win traffic as well as ranking. Either way you are getting your blog seen and this means your airbrush art is getting seen.

Another ways to get your airbrush art seen is to take a look at some airbrush art websites. A lot of these websites offer a gallery that artist can upload images of their work onto for free. This gets you seen by the webmaster of the site as well as other artists. Your work will be put up

there for the sites traffic to see and thus getting you known in the industry. Take the time to submit several pictures of your work to several website airbrush art galleries. Don't depend on just a couple of pictures on one or two sites to get you known.

Myspace is also a great way to get seen and gain some exposure. With Myspace you can create a profile that is dedicated to you as an artist. Upload pictures of your work and take the time to create a couple of videos as well. Create the videos so that they show you in the act of working on your airbrush art. Make sure to use good lighting so that your videos truly capture the art of what you are airbrushing. With millions of users on Myspace you are sure to get yourself seen by people who are interested in your work.

21 Why Airbrush Artwork Works for Everyone

The greatest thing about airbrushed artwork is that it is so versatile; it is an art form can be used for so many different projects, just about anything imaginable. Airbrush artists have used airbrushing for a wide variety of different surfaces for many years by now. The various images that they create are all just as different as the different surfaces used: fingernails, the metal surfaces of motorcycles and automobiles, fabrics of all types, walls of concrete, floors of wood and small decorative items like a cigarette lighter.

A classic painting can be copied and then airbrushed onto canvas in an interesting new way which creates some quick but great wall art. With the airbrushing process the paint is sprayed onto the canvas quickly and more evenly as compared to a painting which has been painted by hand. Also the requirements for time are shortened up when a painting is airbrushed versus painted by hand. Even family portraits might be airbrushed right over the hand painted version in order to bring a more realistic look to the painting.

Your home has many interior spaces that would lend themselves well to airbrush artwork. A very nice mural airbrushed onto a wall gives any room a feeling of extended space and some added interest. You also could airbrush on a much smaller scale by just airbrushing a decorative border on the tops of some walls where they meet the ceiling. Airbrushed borders are more professional looking than the glued on borders made of paper. Therefore, your home's interior can be an interesting canvas for your airbrush artwork; choose bold designs or subtle since the choices are all yours. Your walls are not the only areas to airbrush designs since any area can be used to show your creativity; try airbrushing on your doors, cabinets, toilet seats and even more.

The designs for your interior are probably better if they are not too bold; just some simple pretty flowers or soft ivy trim will work well. Airbrushed clothing is a great way to own one of a kind, unique garments and accessories. The airbrushed art can consist of words added to a t-shirt or other clothing items or it might be your creative original design. No matter what you decide, you will certainly have some items of clothing that no one else has in their wardrobe if you use your own personal airbrushed artwork to them.

Vehicles like cars, motorcycles and trucks are other surface areas for airbrush artists to be very creative and display their best work. Many airbrush artists are making quite a reputation for themselves by doing custom airbrushing artwork onto lots of different vehicles. This complicated artwork is quite expensive but if you learn how to do the airbrushing yourself, you will cut the costs way down. If you do the work yourself you will also have complete control over the final result.

As you may understand by now, airbrushed artwork can be made to fit anyone's needs and tastes. The airbrushed designs are so varied and versatile that your choice can be extreme fantasy art with vivid colors or soft murals with some realistic scenery. The possibilities are endless, variations are unlimited and only the imagination of the artist is in charge. Any surface, any scene and even words or sayings can be used for an airbrushed theme. The airbrushing looks very realistic and saves lots of time over painting by hand. And if you do not want to make the designs yourself, there are plenty of artists for hire.

www.ingramcontent.com/pod-product-compliance
Lightning Source LLC
Chambersburg PA
CBHW071621170526
45166CB00003B/1149